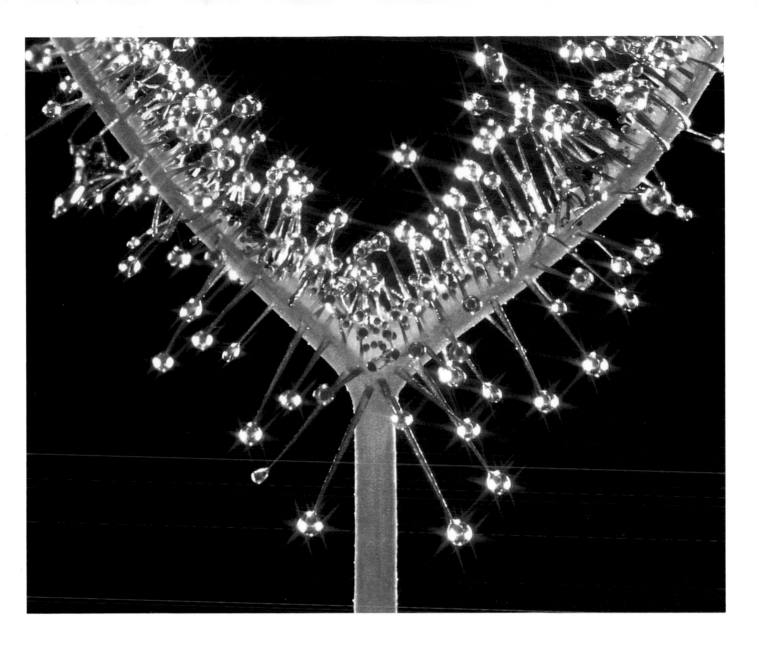

Sundew Stranglers

PLANTS THAT EAT INSECTS

BY JEROME WEXLER

DUTTON CHILDREN'S BOOKS NEW YORK

The photograph on page 5
copyright E. R. Degginger/Photo Researchers;
photographs on pages 14 and 19,
copyright Dr. Jeremy Burgess/SPL/Photo Researchers

Library of Congress Cataloging-in-Publication Data

Wexler, Jerome.
Sundew stranglers: plants that eat insects/text and
photographs by Jerome Wexler. — 1st ed.
p. cm.
ISBN 0-525-45208-7
1. Sundews — Juvenile literature. 2. Carnivorous plants —
Juvenile literature. [1. Sundews. 2. Carnivorous plants.]
I. Title.
QK495.D76 W493 1995
583'.121 — dc20 94-24188
CIP AC

Published in the United States 1995 by Dutton Children's Books,
a division of Penguin Books USA Inc.
375 Hudson Street, New York, New York 10014
Designed by Riki Levinson
Printed in Mexico
First Edition
1 3 5 7 9 10 8 6 4 2

This herbe is of a very strange nature and marvelous:
for although that the sonne do shine hoate, and a long time thereon,
yet you shall finde it alwayes full of little droppes of water:
and the hoater the sonne shineth . . . the more bedewed,
and for that cause it was called Ros Solis *in Latine,*
which is to say in Englishe,
the Dewe of the Sonne, or Sonnedewe.

—Henry Lyte, 1578

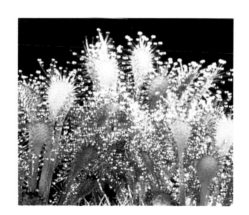

Long ago, when Amerindian tribes along the eastern coast of North America planted corn, they placed a fish in the earth next to each seed. As the fish's body decayed in the soil, the plant absorbed the organic materials from which the fish was made. The fish was fertilizer for the plant. It gave the corn what the soil could not.

There are plants that use insects in a similar way. They trap them for their nutrients. The insects give the plants what the soil and air do not provide.

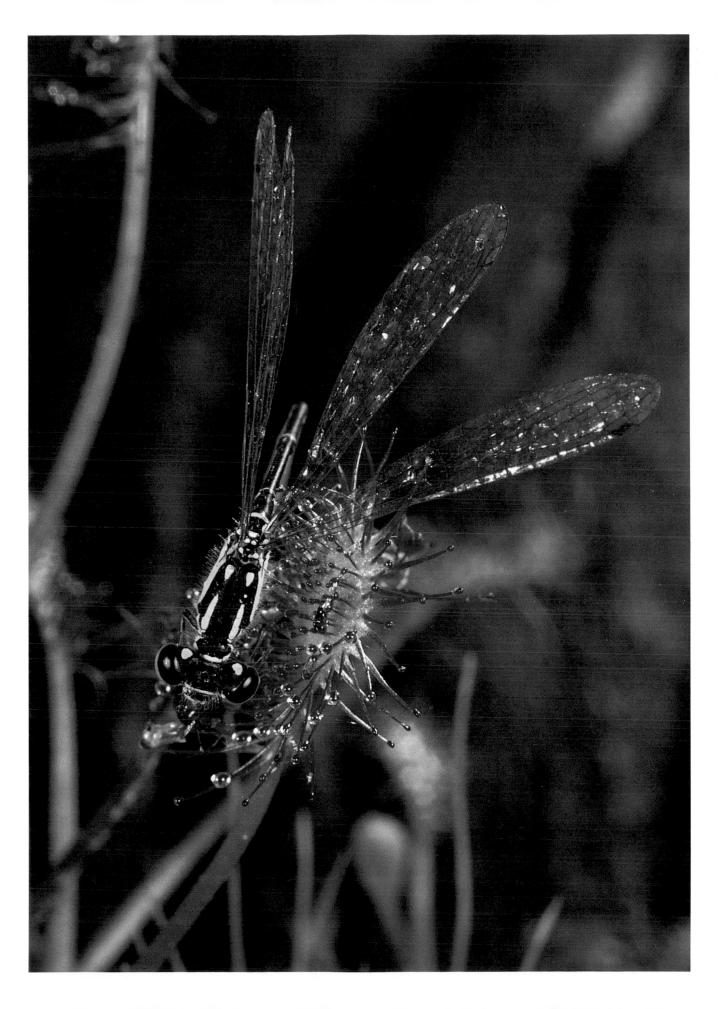

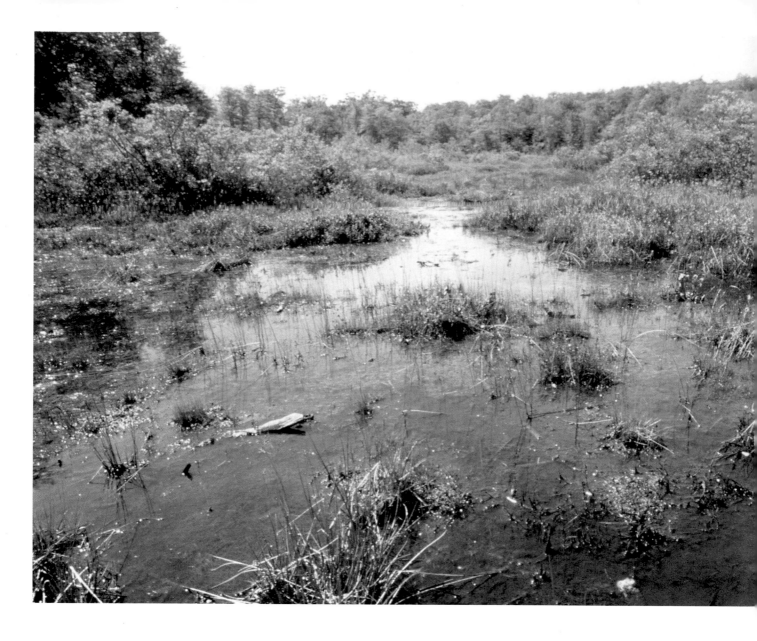

Plants that trap insects and eat them are called carnivorous, or insec-
tivorous, plants. About five hundred kinds exist around the world.
Mostly they live in wet, humid places such as bogs, swampy meadows,
or pine barrens, where the acidic soil is poor in nitrogen and minerals.

Like all green plants, carnivorous plants can make their own food.
In fact, they make the three main food groups that we humans also
depend on: carbohydrates, fats, and proteins. In the presence of sunlight,
and using the green pigment chlorophyll in their leaves, plants turn
water and carbon dioxide into sugars and starches. These carbohydrates

give plants the energy that powers their growth. Green plants make fats, too, for their seeds. And they make proteins for a variety of cell functions, including strength and structure.

To make proteins, plants need nitrogen, phosphorus, and some minerals. They need nitrogen also to copy and repair their DNA, the genetic material that governs their lives and the lives of the plants that grow from their seeds and cuttings.

Although the air around us contains plenty of nitrogen gas, many plants cannot use it in that form. In order for nitrogen to enter their roots, it must first be "fixed," or combined with other chemicals. Soil fertilized by compost is rich in nitrogen compounds, minerals, and other organic materials that were once part of living plants and animals. And certain microscopic single-celled bacteria can do what more so-phisticated, multicelled plants and animals cannot. They can convert, or fix, nitrogen gas from the air into a chemical form that plants can draw up through their roots and trans-port to their stems and leaves.

But what about plants that live in poor, boggy soil that contains little nitrogen or bacteria to fix it?

These plants get their nitrogen, phosphorus, and minerals another way. To carnivorous plants, insects are flying, creeping, crawling packets of fertilizer. Over millions of years, they have evolved ingenious and mysterious ways of attracting and trapping them.

The Venus's-flytrap is a carnivorous plant. It has trigger hairs on the inner surface of its leaves. When an insect lands and touches two or more hairs, an electrical signal travels along the surface of the leaves, and—gotcha! In one-tenth of a second, the leaves snap shut like hungry jaws.

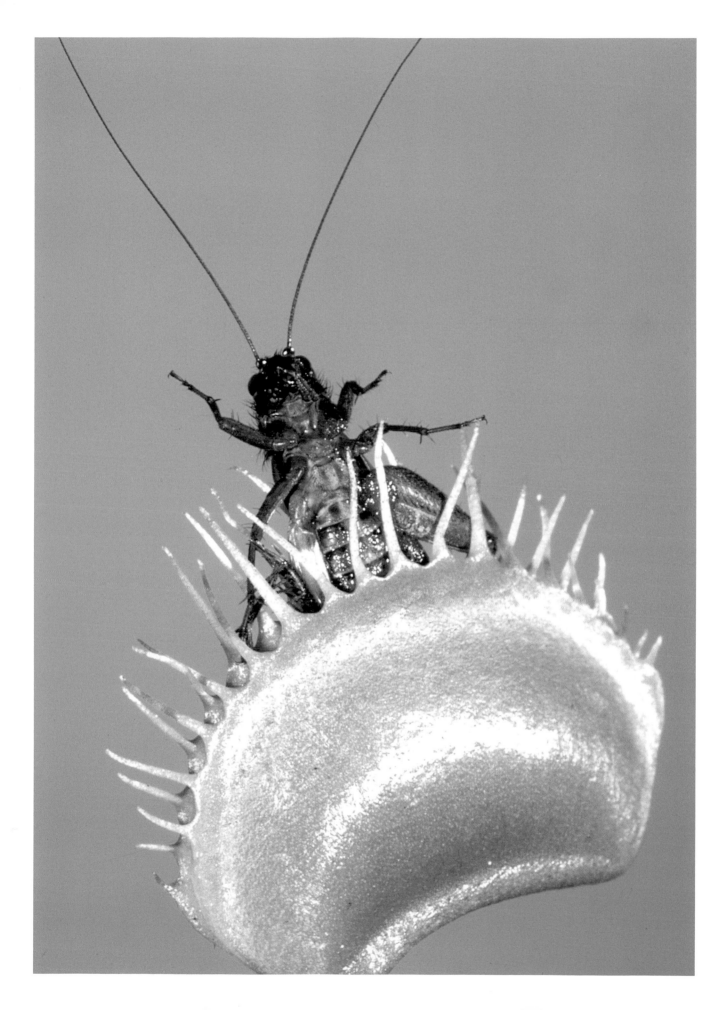

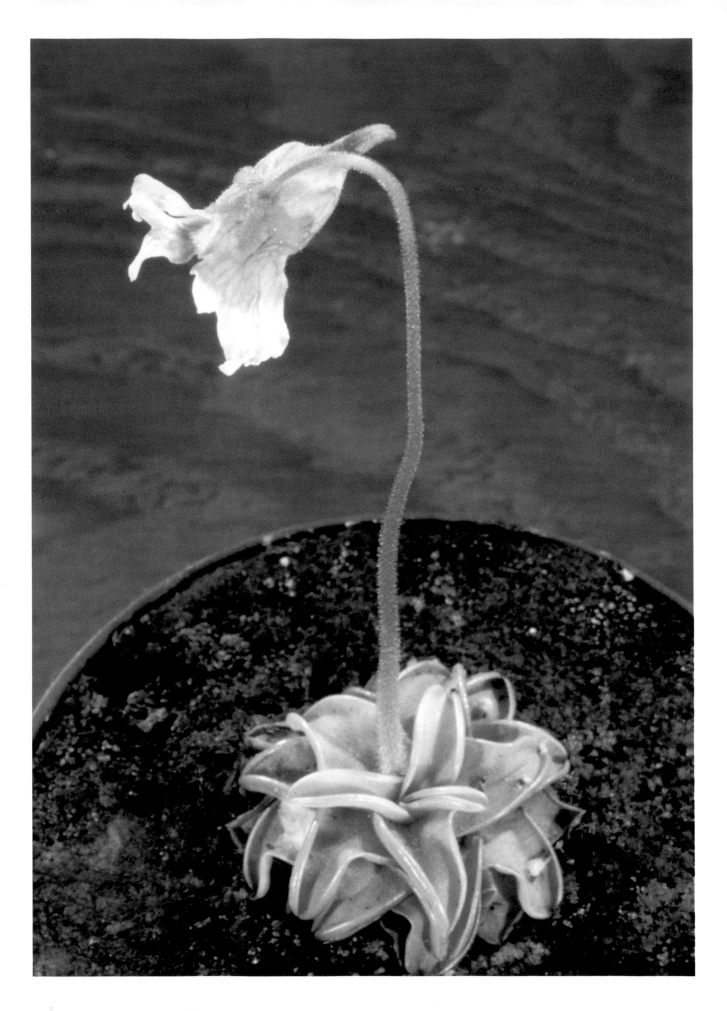

The leaves of the butterwort plant produce greasy droplets that insects stick to. The leaf edges then curl around the trapped prey. Special proteins, called enzymes, dissolve the insects, and the plant absorbs the nutrients.

People in Scandinavia have used butterwort leaves to curdle milk in order to begin the butter- and cheese-making process.

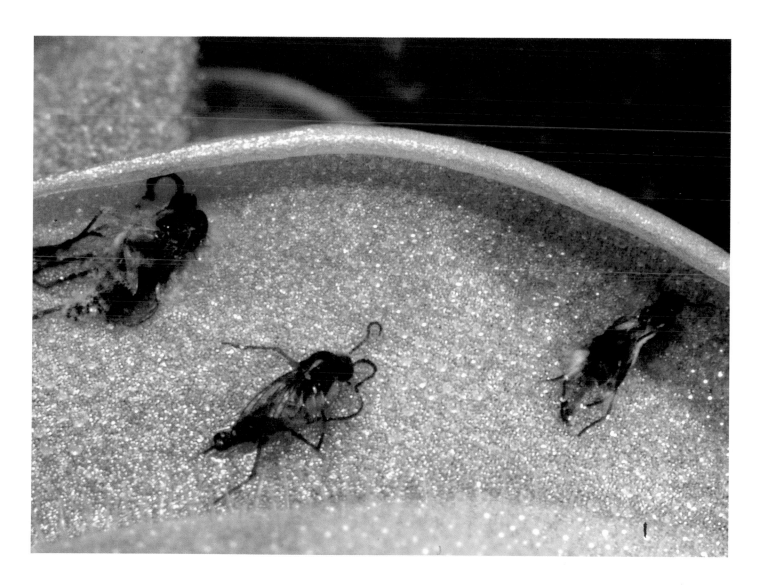

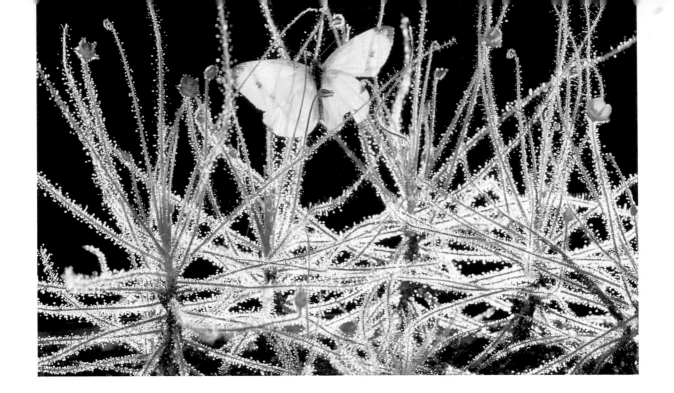

The leaves and stems of this rainbow plant *(above)* are covered with clear, sticky droplets. When two or more plants grow together, their leaves intertwine, forming a netlike hedge. The hedge is particularly good for snaring large, flying insects.

The leaves of the teasel plant *(below)* catch rainwater to form a tiny lake. Often insects drown there, and it is thought that the plant absorbs their nutrients.

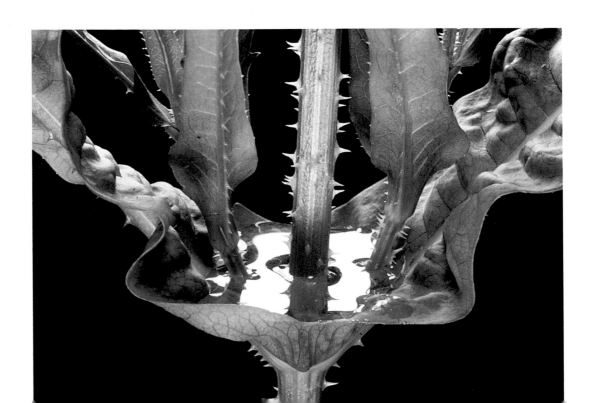

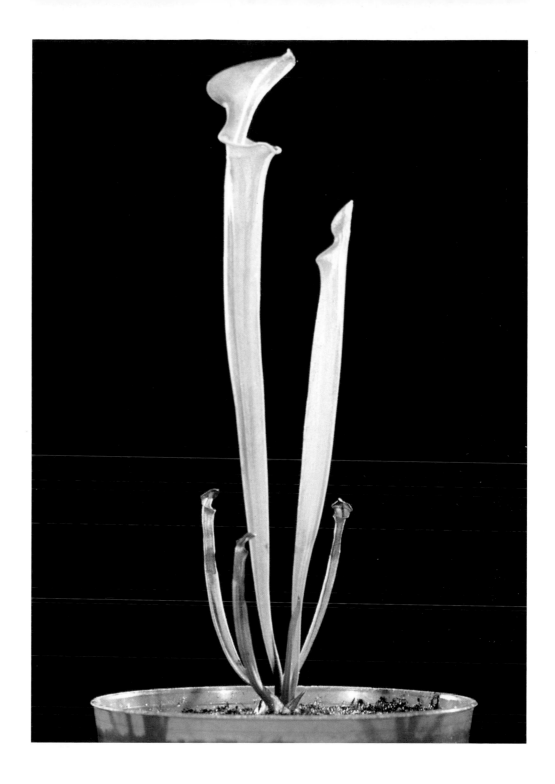

This pitcher plant "swallows" insects. It lures them into its long, slippery-sided pitcher with a sweet-smelling nectar. Then stiff, downward-pointing hairs keep the insects from climbing out. Enzymes dissolve the soft parts of the insects' bodies, and the pitcher plant "drinks" its fertilizer.

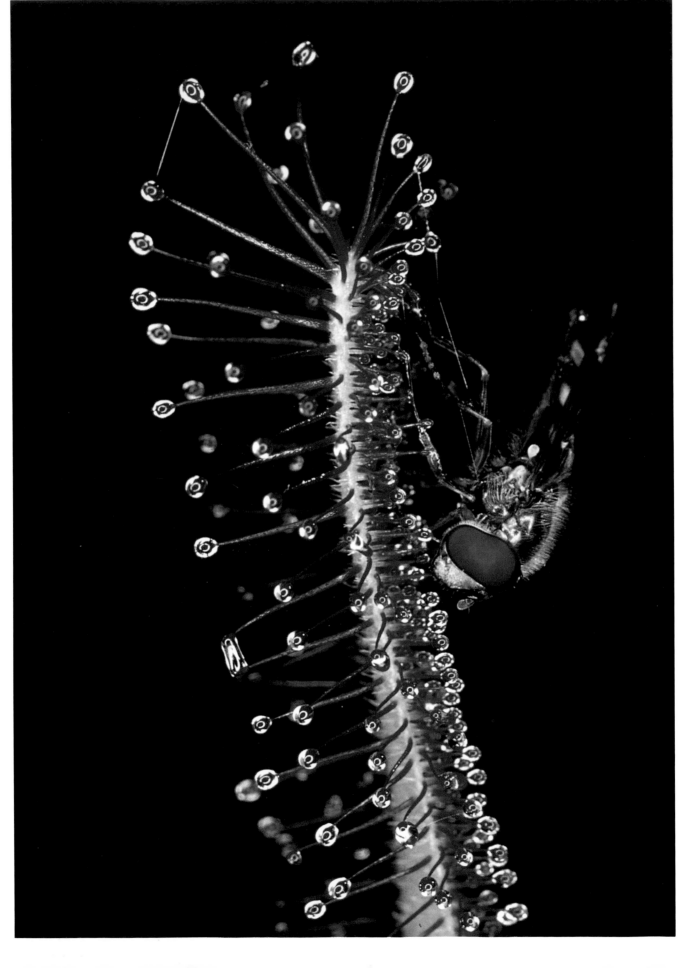

Sundews are carnivorous plants with leaves that sparkle like dew in the sun. That's where the name comes from. But that glistening dew is really a sticky substance that will hold fast any insect that touches it.

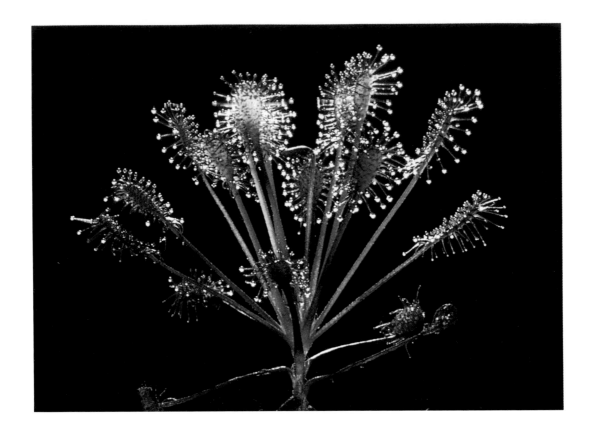

Sundews can be found on every continent on Earth (except Antarctica). The sundew shown above grows in North America, in Europe, and across the former Soviet Union all the way into Asia. Chances are that some kind of sundew may be growing near you. So let's look more closely at sundews.

There are over one hundred different kinds, or species, of sundews. This pygmy sundew is from Australia. Its leaves are only a few millimeters long. Compare it in size to a penny.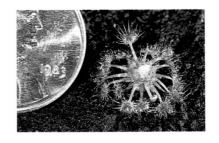

There are also sundews whose leaves measure almost two feet in length. Such giant sundews grow in South Africa, Australia, along the Gulf Coast of the United States, and in other tropical areas of the world.

The kind of sundew pictured below originated in the Cape region of South Africa, but many plant lovers around the world raise it at home. Its scientific name is *Drosera capensis*. *Drosera* is the genus, or group name. It identifies the large group to which all sundews belong. *Drosera* tells scientists the plant is a sundew and not, for instance, a butterwort (genus *Pinguicula*) or a Venus's-flytrap (genus *Dionaea*) or a rainbow plant (genus *Byblis*). *Drosera* comes from the Greek word *droseros,* which means "dewy." The species name *capensis* identifies what kind of sundew this *Drosera* is. *Capensis* means "cape," and refers to Africa's Cape of Good Hope, the plant's home region.

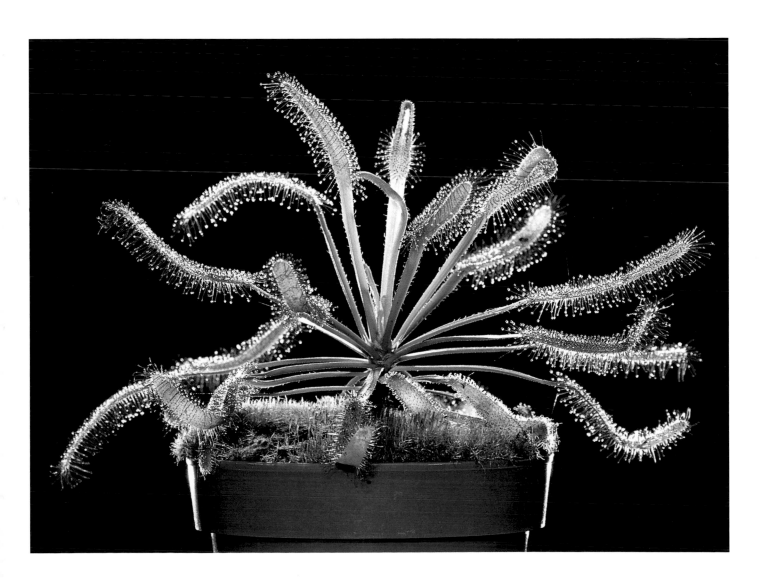

Sundews are excellent insect catchers. Their leaves are covered with hundreds of tiny tentacles, each topped by a round gland. These tentacles, or "stalked glands," as they are sometimes called, attract insects and then strangle them!

The glands are groups of cells that carry out important functions for the plant. They secrete the sticky mucilage that glitters in the sun and lures insects to the plant, holding them fast. The glands may also produce a honey-sweet aroma that attracts insects, although nobody knows for certain. And the glands secrete digestive enzymes that liquefy the insect's soft tissues. After that, they help absorb the nutrients the plant needs for growth.

The glands are sensitive to the slightest touch. An insect landing on a sundew leaf can't help brushing against at least a few tentacles. As it struggles to free itself, it comes into contact with still more. Each gland the insect touches is stimulated to send important signals down its stalk, telling the whole tentacle to bend.

The tentacles begin to do just that, pressing the struggling insect toward the surface of the leaf. The glands on the bending tentacles also send signals to nearby tentacles. They, too, bring their sticky tops in contact with the insect. In some species, the signals even travel to the leaf, and it begins to curl around the insect like a strangler.

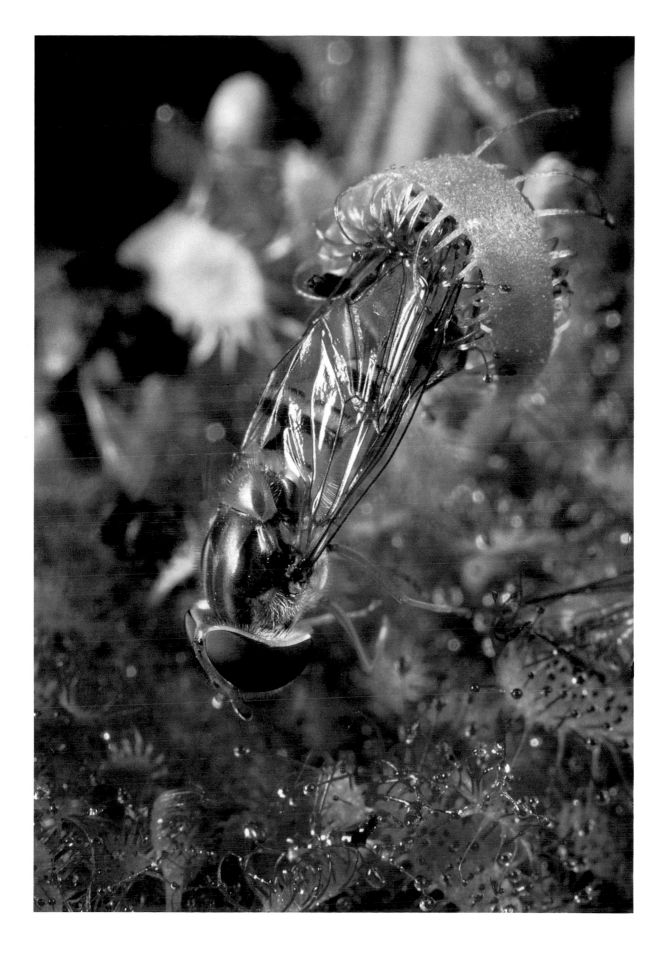

The photograph below shows a tentacle that has been removed from a leaf. A toothpick was then pressed into its gland. When the toothpick was pulled away, the mucilage would not stop sticking. In the same way, the sticky mucilage will not let an insect pull free.

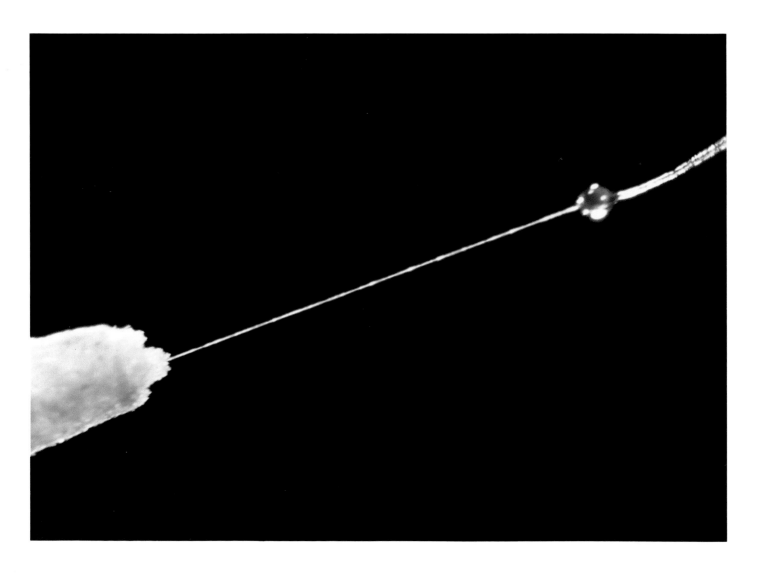

Sundews have fascinated people for centuries. At first it was thought that sundews had to protect themselves from insects, and that was why they captured them. But about 120 years ago, the British biologist Charles Darwin became curious about carnivorous plants. He asked himself a lot of questions and tried many experiments on sundews to answer them.

Eventually he understood a great deal about the way sundew tentacles and leaves behave. It was Darwin who demonstrated that far from protecting themselves from insects, sundews caught them, digested their soft parts, and absorbed their nitrogen and minerals.

Darwin wondered what made the sundew tentacles and leaves bend. He tried out various foods and chemicals, among them the white of an egg. Let's try a little egg white ourselves and see what happens.

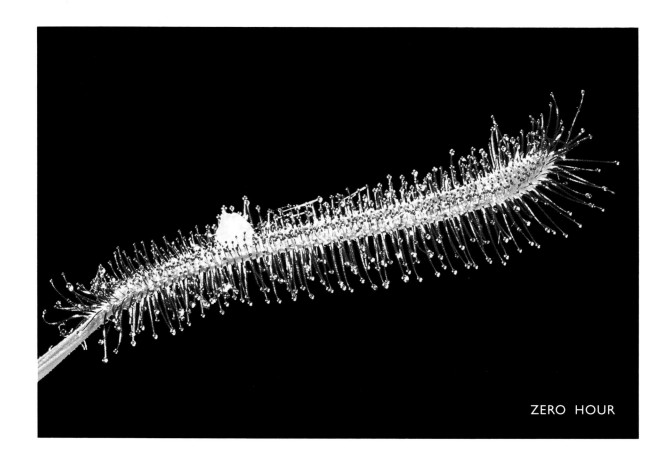

ZERO HOUR

Here is a bit of egg white on a leaf of *D. capensis*. Will the tentacles respond? Sure enough, within about ten minutes, they begin to lean toward it. Within twelve hours, the leaf itself has begun to change position. What caused this action?

Egg white is made up of proteins. All proteins contain nitrogen and some minerals, as well as carbon, oxygen, hydrogen, and sulphur. So the plant senses something useful here.

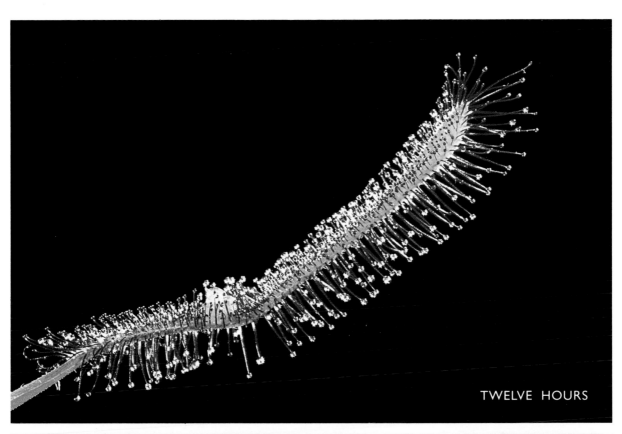

TWELVE HOURS

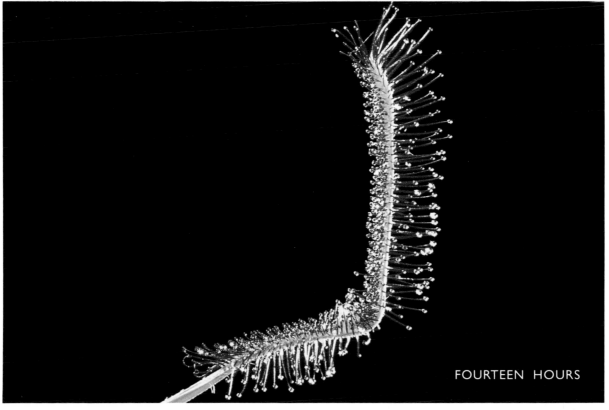

FOURTEEN HOURS

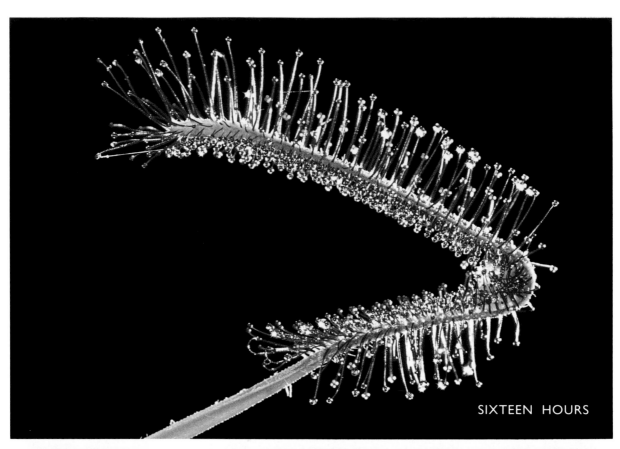

SIXTEEN HOURS

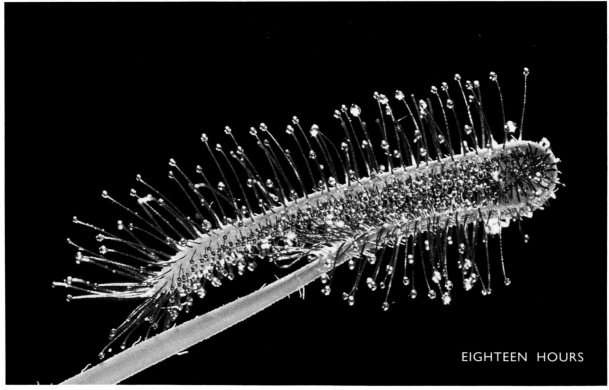

EIGHTEEN HOURS

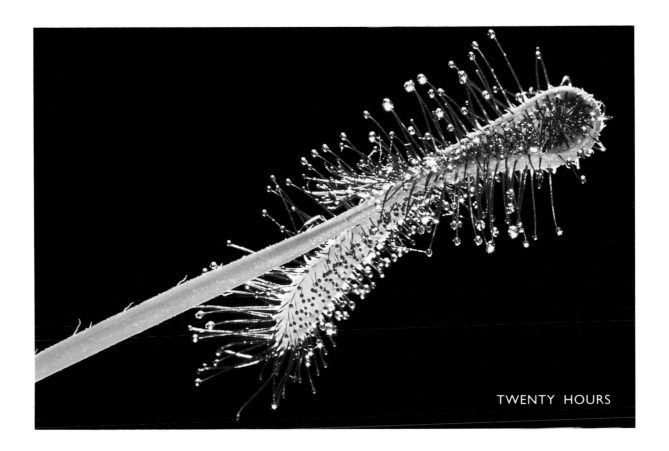

TWENTY HOURS

As time goes by, the leaf continues to move. What tells it to turn and fold? And how does it do so? The glands touching the egg white are stimulated by the egg-white proteins. Each gland keeps sending chemical messages down its own tentacle, to nearby tentacles, and to the leaf.

A gland's message tells the cells on one side of its tentacle—the side farthest away from the trapped protein source—to grow. So they elongate. The cells on the other side—near the trapped material—stay the same. They do not grow. This one-sided elongation causes the tentacle to bend. In a similar way, the elongation of cells on one side of the leaf but not on the other causes it to fold and curl around the food it has trapped.

In a sundew, the growth that causes movement starts within about ten minutes and can continue for several days.

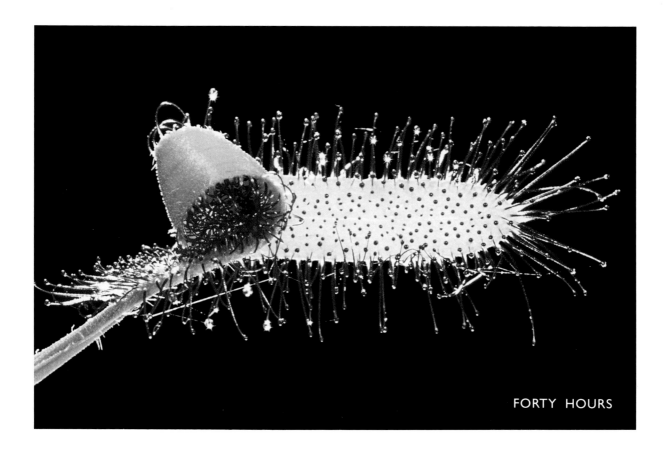

FORTY HOURS

During the next three days, the leaf keeps turning and curling. If the egg white were an insect, the glands touching it would be stimulated to secrete digestive enzymes. These liquid enzymes would break down the insect's soft body parts. Then they would help absorb the digested material.

But we fed our leaf a piece of egg white, not an insect. Will the leaf digest and absorb it?

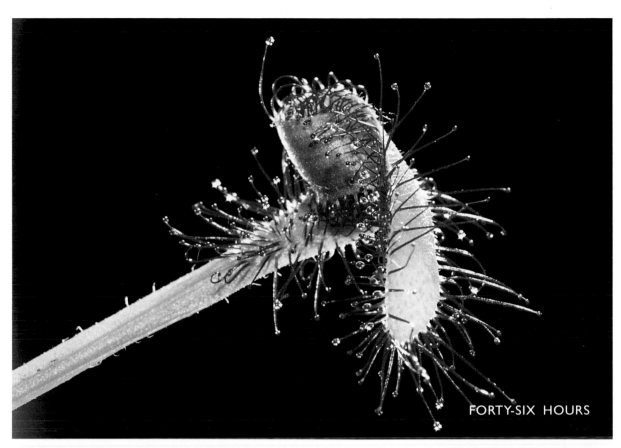

FORTY-SIX HOURS

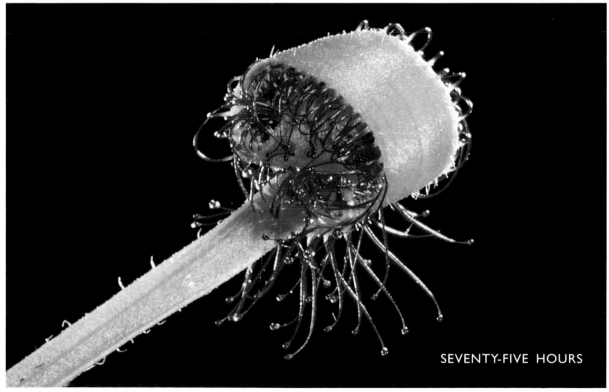

SEVENTY-FIVE HOURS

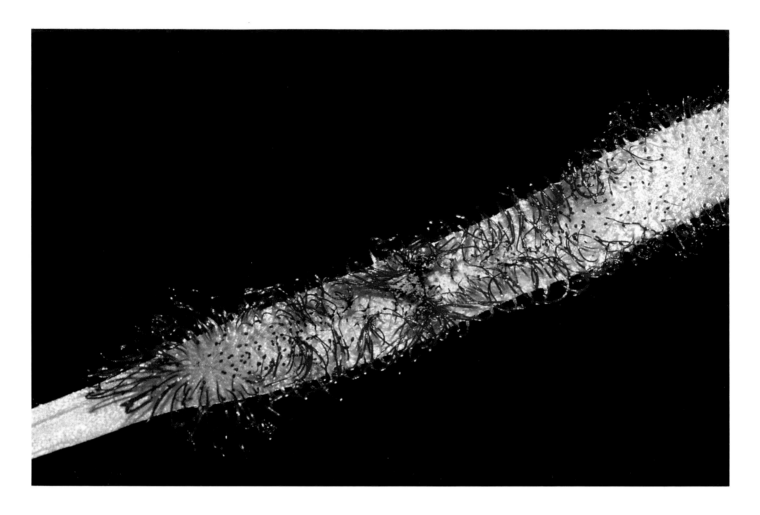

Ten weeks later, the leaf of *D. capensis* opens. There is no sign of egg white, but the leaf is in terrible shape. Perhaps the piece was too big. Or, since digestion does produce waste products, perhaps there was an excess and that harmed the leaf.

When a sundew captures an insect, it usually takes between five days to two weeks for digestion and absorption to be completed. Then the leaf opens, and only the insect's hard outer shell, or exoskeleton, is left. Wind or rain carries that away, and the tentacles are ready for another capture. Each tentacle on a sundew leaf can go through the process of bending, digesting, and absorbing about three times before it will no longer be of use to the plant.

Can a sundew leaf be fooled? Charles Darwin tried to do so. He placed sand and bits of glass on a leaf. He even tickled tentacles with a stick. A few responded, but only for a short time.

In the photograph below, a piece of aquarium gravel has been placed on a leaf. It sticks to a few tentacle tops, but nothing more happens. The gravel has no nutritional value for the plant, so the glands are not stimulated to send their chemical "bending" messages.

Present-day researchers have learned that the gluey coating around the gland is a sugary substance. Anything that stimulates the gland must first penetrate the sugary mucilage. It does not take much to do that—a fragment of hair, the slenderest insect wing. Researchers have even sprayed sundew leaves with fertilizer and seen the tentacles and leaves respond. The fertilizer mist dissolves through the sugar coating and stimulates the glands.

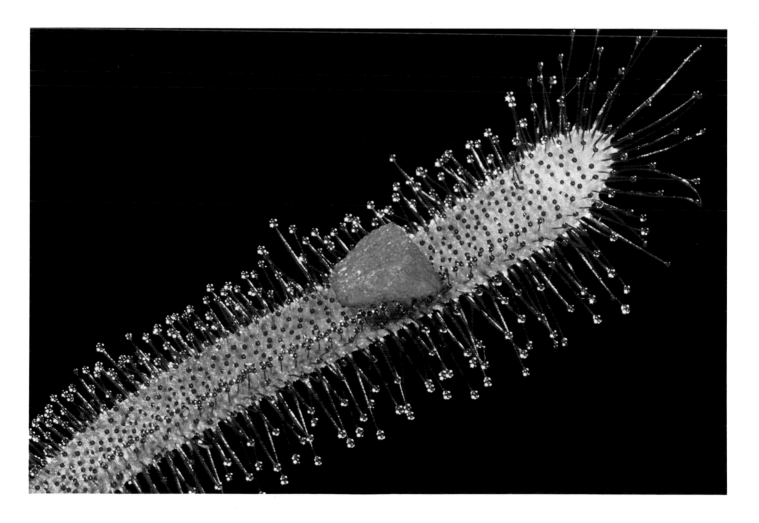

The best way to enjoy and study sundews is to raise
them yourself. You can raise them indoors or outdoors, in
full or partial sun, or even in the shade. Indoors, a sunny
window or a nearby fluorescent light is fine.

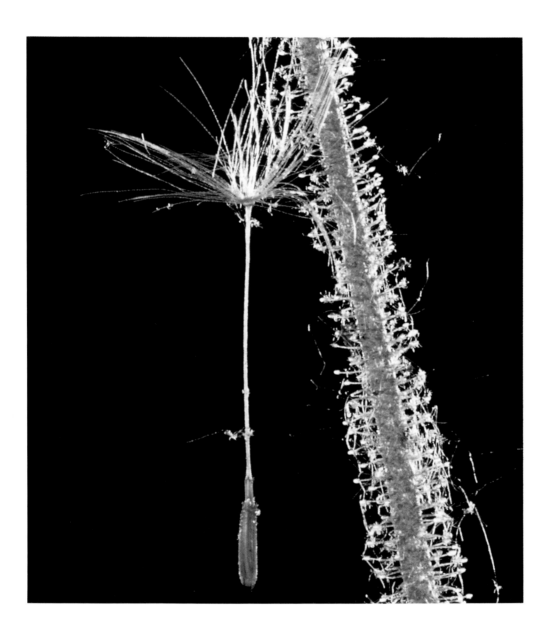

Outdoor plants grow well but are not always suitable
for photographic purposes. They tend to pick up all kinds
of "garbage," from dust to seeds.

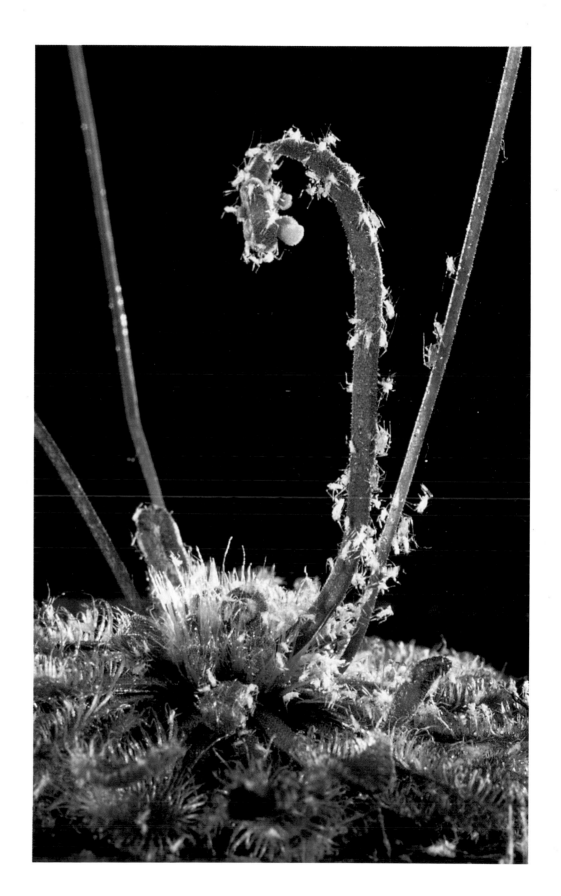

Plus some aphids.

One of the easiest sundews to raise is called *Drosera rotundifolia*. Its seed capsule has little windows. The slightest breeze or movement scatters seeds everywhere.

And the seeds are tiny.

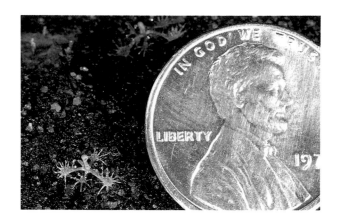

Small seeds mean small seedlings.

But those all-important glands are already formed. Indoors, seeds
can be planted almost any time of the year. Outdoors, spring is best.

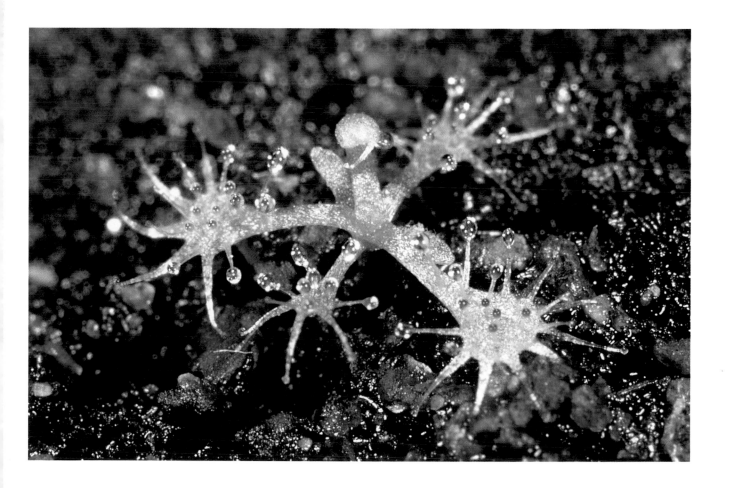

This beautiful *D. rotundifolia* plant grew from a seed within about six months.

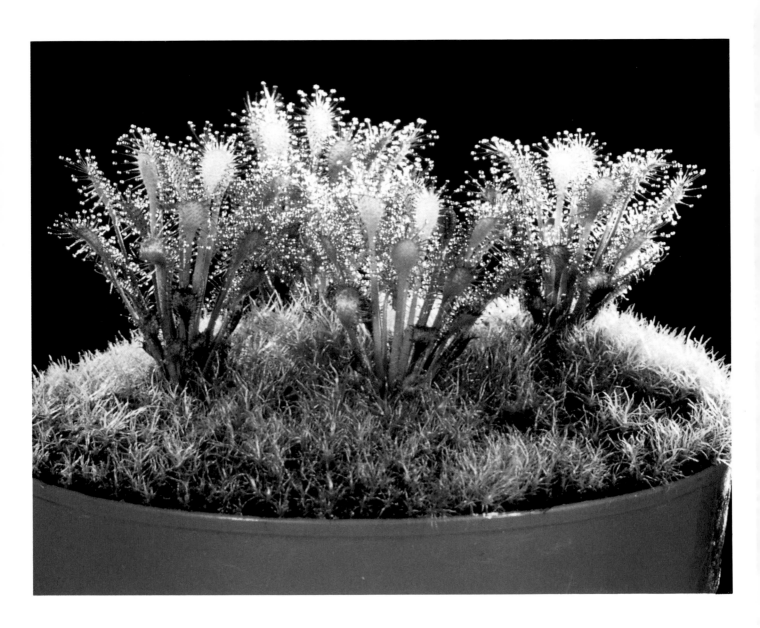

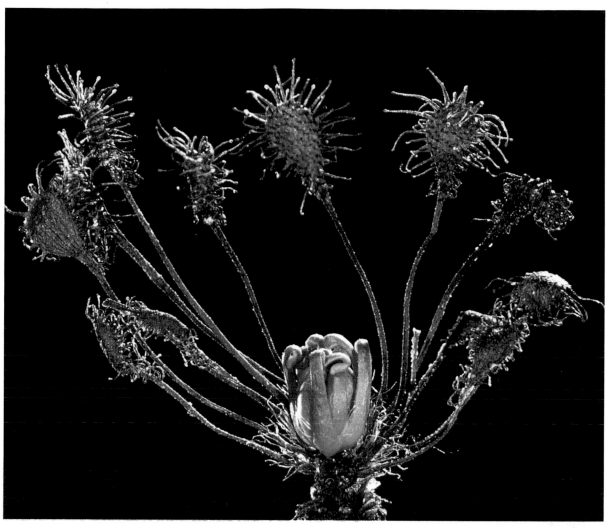

D. rotundifolia lives in temperate climates where the seasons change. In winter, the plant goes into a resting phase, even when kept as a houseplant. A small, tight clump of leaves, called a winter bud, forms in the center of the plant. Everything else dies. Producing a winter bud like this is the way many sundew species survive the cold until spring arrives.

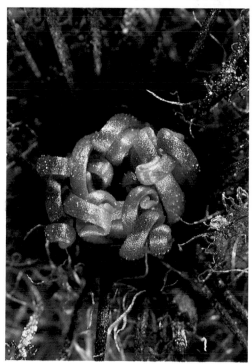

Spring means flowers, a plant's way to make seeds. Some pygmy sundews produce flowers almost as big as themselves. The inner parts of a plant's flower—the sexual, or reproductive, organs—are very important for seed making.

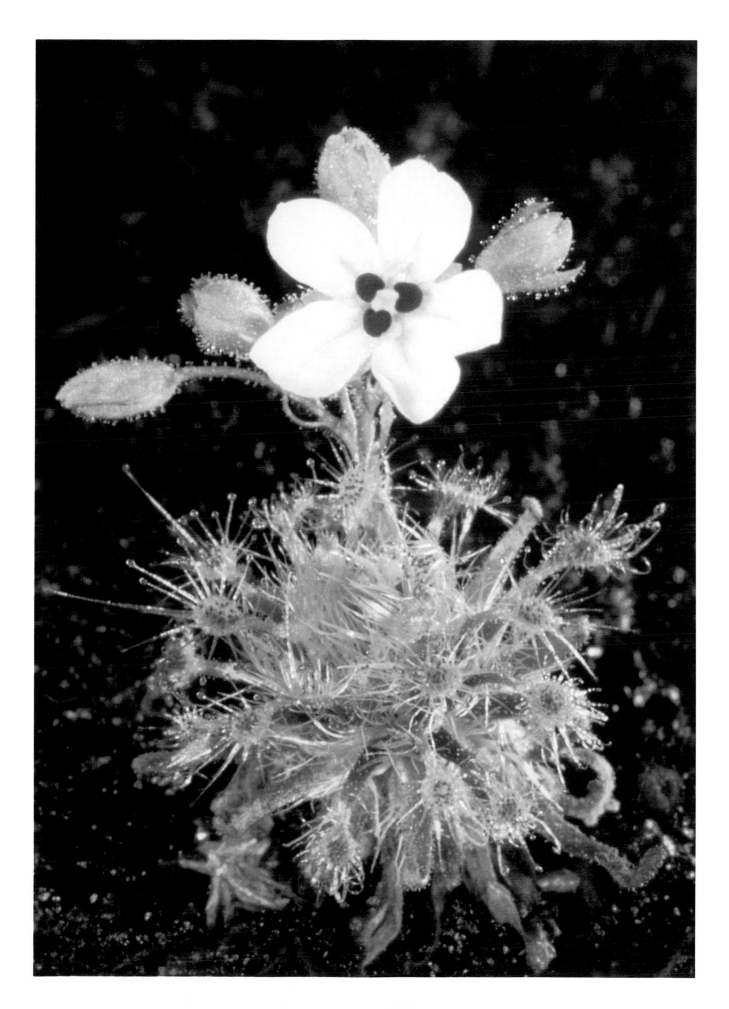

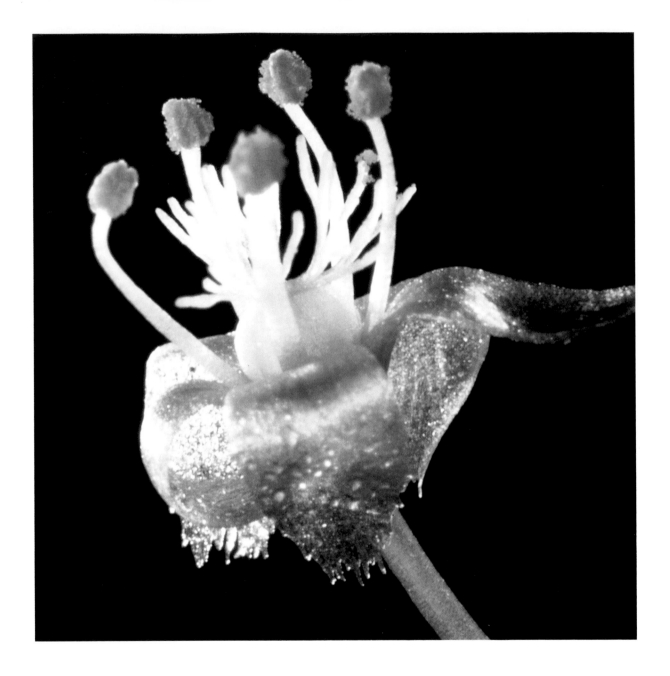

 The petals on this flower of *Drosera binata* have been peeled away for a closer look at the reproductive organs. You can see five male parts, called stamens, surrounding a female part. The reproductive organs are so close together that the slightest movement will transfer pollen from the top of a stamen to the top of the female part. If seeds result, flowers like this are considered to be self-pollinating. Plants that are not self-pollinating must rely on insects or the wind to transport their pollen to another plant of the same kind.

In the photo below, you can see a single stamen of a *Drosera binata* flower together with the female reproductive organ. The stamen consists of an anther, which produces orange-colored pollen grains, supported by a filament. Inside each pollen grain, two male sex cells develop. When they are mature, the anther opens, releasing the pollen.

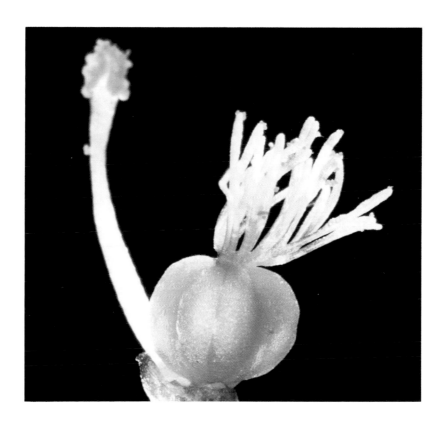

The female reproductive organ has three sections: a feathery stigma at the top, to catch the pollen; a round ovary that contains ovules, or female sex cells, at the bottom; and, in between, a style. The style here is so short it seems to be missing, but it's not.

When a grain of pollen lands on the stigma, a rootlike tube grows from the pollen grain. It carries the two male sex cells down the style into the ovary. There one unites with, or fertilizes, an ovule. From that union a seed will form. The other male sex cell stimulates the ovary to produce food for the new seed.

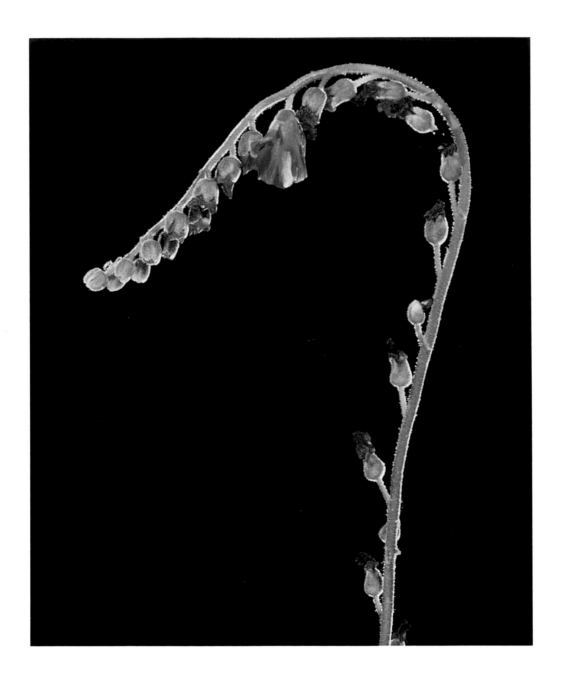

This is the flower stalk of *D. capensis*. It contains between fifteen and twenty self-pollinating flowers. Each day, starting at the bottom of the stalk, one flower opens and then closes. By the time the topmost flowers open, the ones near the bottom have produced mature seeds. The seeds can be planted right away or stored for several months in a refrigerator or freezer.

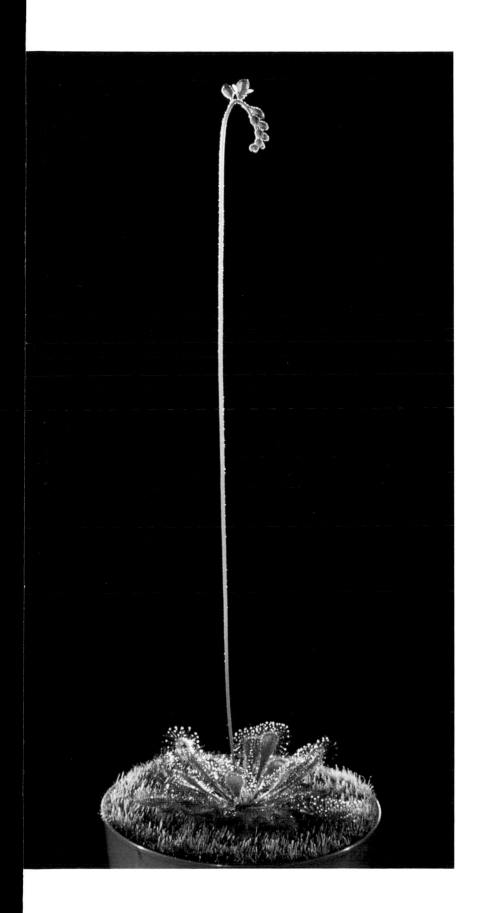

A sundew that is not self-pollinating depends partly on insects to transfer its pollen from anther to stigma. But if a sundew captures and digests insects, how will pollination occur? Over time, some sundews have adapted to this problem by bearing their flowers high above their trapping leaves.

Many years ago, people who raised sundews noticed that in some species, when a leaf was injured, a new plant would form at the site of injury. This type of reproduction, which doesn't involve seeds, is called vegetative reproduction, or asexual reproduction. The new plant does not grow from the union of male and female sex cells.

In many species, almost any part of a sundew plant can be used for asexual reproduction: the flat part of the leaf (blade); the leaf stalk (petiole); and the roots and stems. Remove one or two leaves from a plant. Cut the blade and the petiole into half-inch pieces and place them top-side down on moist soil.

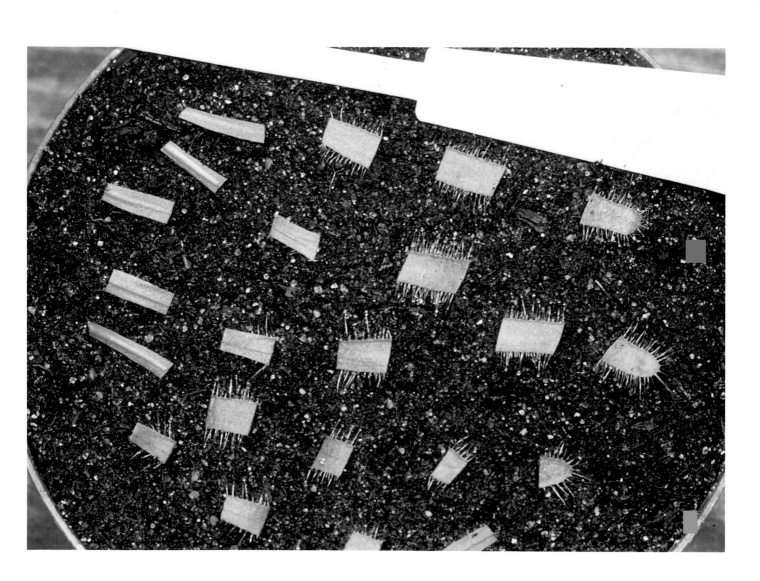

Cover with a piece of transparent plastic. There should be about a half-inch space between the soil and the plastic. The easiest way to do this is to place three or four short sticks around the circumference of the pot.

In two or three weeks, each piece of leaf will produce one (and sometimes two) new plants.

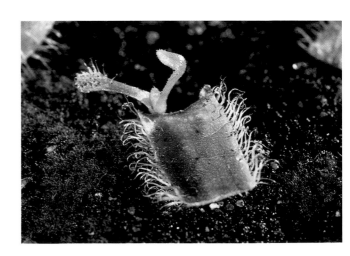

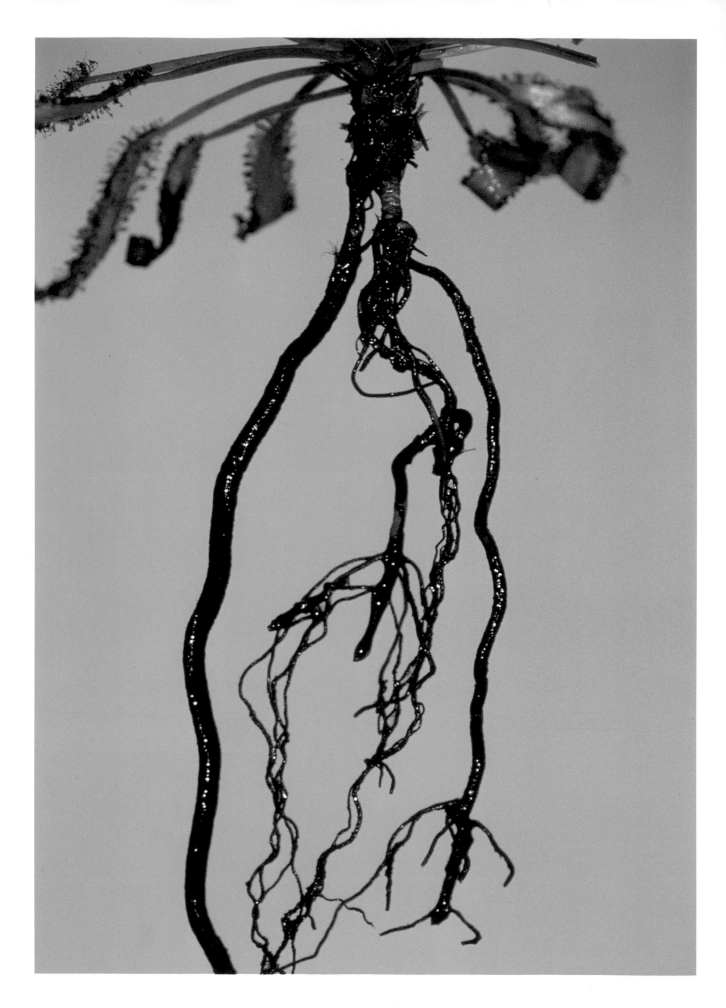

At left is a photo of the roots of *D. capensis*. You can see two types of roots—thick and fine. Both will produce new plants. Cut some off. (Leave about three inches of roots on the plant and repot it so that it can continue growing.) Recut the root pieces so that they are about an inch and a half long. Moisten a handful of sphagnum moss. Place the moss and the root sections in a plastic bag and shake it so that the roots are more or less covered. Close the bag and leave it alone for several weeks.

When you open the bag,
it will be full of new plants!

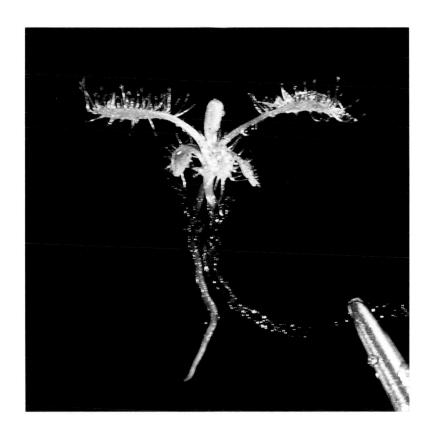

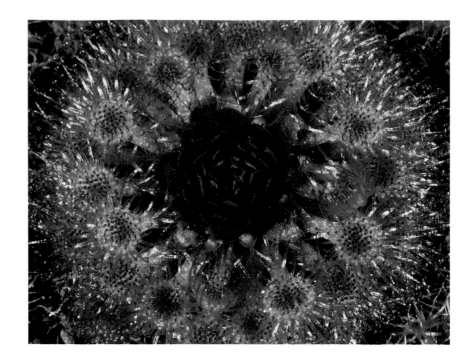

In North America, we tend to think of the changing seasons in terms of temperature—summer is warm, winter cold, and so on. But in some areas of the world, such as Australia, the changing seasons are also experienced in terms of moisture. There is a dry season and a rainy season.

Some pygmy sundews that grow in Australia have adapted to the dry season by reproducing in an unusual way. As the dry season approaches, strange leaf forms, called gemmae, develop in the center of the plant.

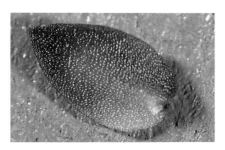

Seen close up, the gemmae look like tiny leaves without stems.

All during the dry season, the gemmae just sit where they were formed. When the rain does begin, it scatters them, and each gemma forms a new plant.

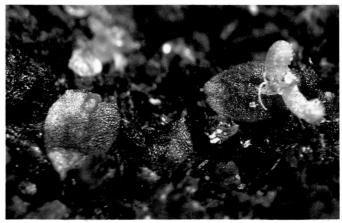

 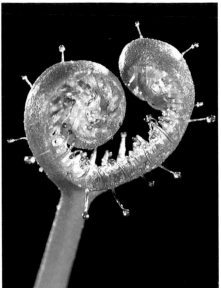 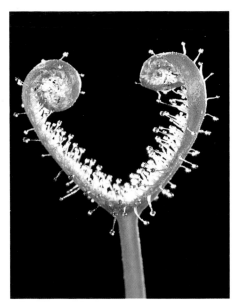

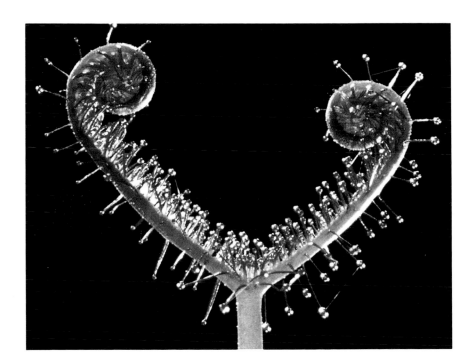

The ability to make seeds, to produce gemmae, or to grow from injuries or cuttings—all are ways in which sundews make more of themselves. Individual sundew plants may die, but their offspring will survive and grow. In this way, the various species of sundews secure their future on Earth. Let us do what we can to make sure these fascinating plants continue to enrich our planet.